Words of Faith

A Coloring Book to Bless and De-Stress

PARACLETE PRESS

PARACLETE PRESS

BREWSTER, MASSACHUSETTS

2015 First printing

Words of Faith: A Coloring Book to Bless and De-Stress

Copyright © 2015 by Paraclete Press, Inc.

ISBN 978-1-61261-767-1

These hand-drawn designs were created by monastics from the Community of Jesus, an ecumenical monastic community rooted in the Benedictine tradition.

Scriptures marked NRSV are from the New Revised Standard Version Bible, copyright 1989, Division of Christian Education of the National Council of the Churches of Christ in the United States of America. Used by permission. All rights reserved.

Scriptures marked NIV are from the Holy Bible, NEW INTERNATIONAL VERSION®, NIV® Copyright © 1973, 1978, 1984, 2011 by Biblica, Inc.® Used by permission. All rights reserved worldwide.

Scriptures marked ESV are from The Holy Bible, English Standard Version® (ESV®), copyright © 2001 by Crossway, a publishing ministry of Good News Publishers. Used by permission. All rights reserved.

Scriptures marked THE MESSAGE are from THE MESSAGE. Copyright © by Eugene H. Peterson 1993, 1994, 1995, 1996, 2000, 2001, 2002. Used by permission of Tyndale House Publishers, Inc.

Scriptures marked NKJV are from the New King James Version®. Copyright © 1982 by Thomas Nelson. Used by permission. All rights reserved.

The Paraclete Press name and logo (dove on cross) are trademarks of Paraclete Press, Inc.

10 9 8 7 6 5 4 3 2 1

Published by Paraclete Press
Brewster, Massachusetts
www.paracletepress.com

Printed in the United States of America

*S*ometimes coloring is just coloring. To put crayons to paper and create a rainbow of marks and swaths is relaxing, playful, and maybe even artistically satisfying. But sometimes coloring is more. To put colored crayons, markers, or pencils to paper is to create a pathway to the numinous. Coloring invites the body and the senses into an experience of inner stillness. While the hand moves, the mind and the body slow down. The heart and the ears open carving a space for rich silence and an opportunity for God to speak.

—SYBIL MACBETH,
author of *Praying in Color: Drawing a New Path to God*

Faith

We live by faith, not by sight.

2 CORINTHIANS 5:7 [NIV]

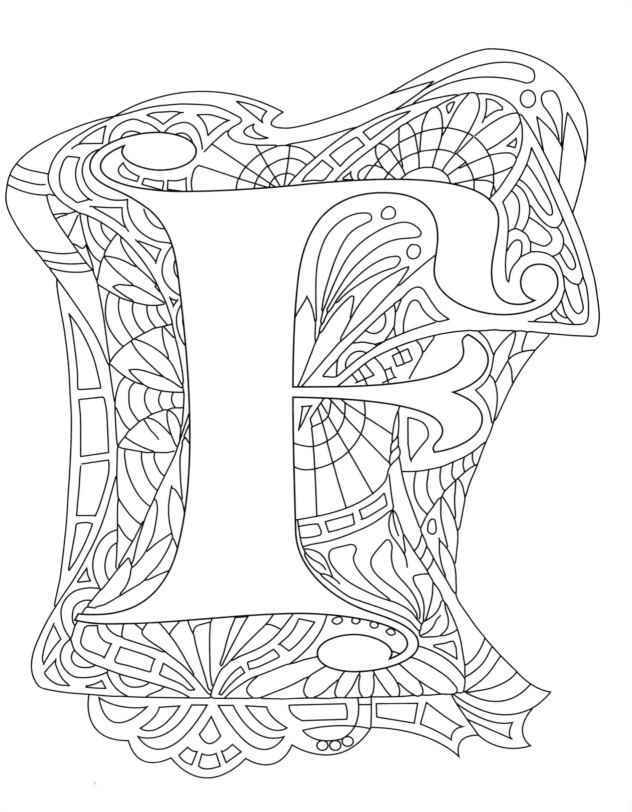

Rejoice in hope.

ROMANS 12:12A [NRSV]

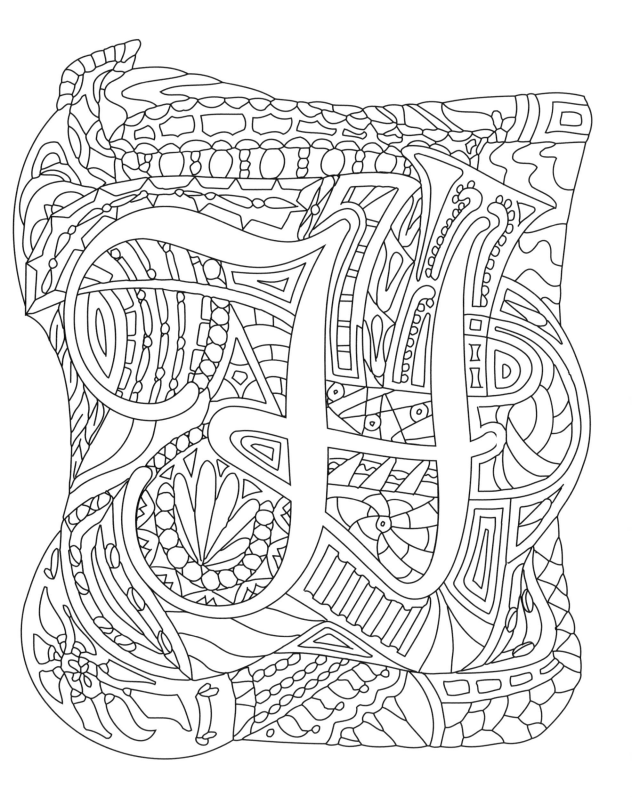

Faith, hope, and love abide, these three;
but the greatest of these is love.

1 CORINTHIANS 13:13 [ESV]

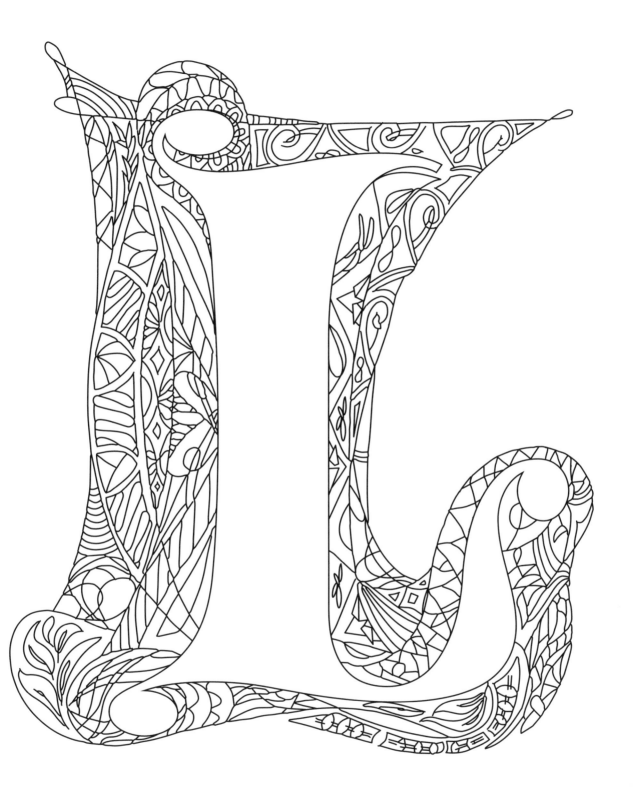

May the God of hope fill you with all joy and peace.
—ROMANS 15:13A [ESV]

The eternal God is your refuge.

DEUTERONOMY 33:27A [NIV]

Creator

The Spirit of God has made me;
the breath of the Almighty gives me life.

JOB 33:4 [NIV]

Healing

He heals the brokenhearted and
binds up their wounds.

PSALM 147:3 [ESV]

Now you are light in the Lord.
Live as children of light.
EPHESIANS 5:8 [NIV]

To you it has been given to know
the mysteries of the kingdom of God.

LUKE 8:10A [NKJV]

The truth will set you free.

JOHN 8:32B [ESV]

Spirit

Those who are led by the Spirit of God
are the children of God.

ROMANS 8:14 [NIV]

Blessed are the merciful, for they shall obtain mercy.

MATTHEW 5:7 [NKJV]

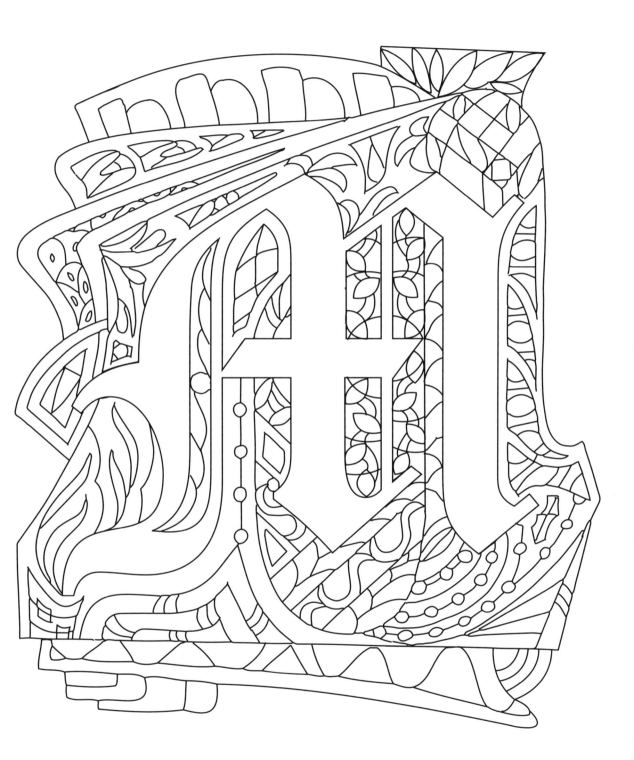

Be Not Afraid

Do not fear, for I have redeemed you.

ISAIAH 43:1B [NRSV]

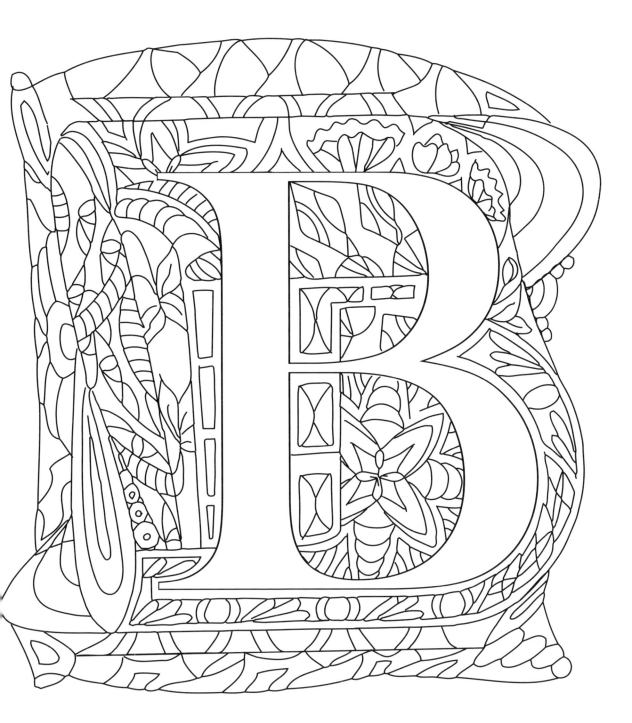

Heaven

I will come again and will take you to myself,
so that where I am, there you may be also.

JOHN 14:3B [NRSV]

Wisdom

I pray that . . . the Father of glory may give you
a spirit of wisdom and revelation as you come to know him.

EPHESIANS 1:17 [NRSV]

The grace of the Master Jesus be with all of you.

REVELATION 22:21 [THE MESSAGE]

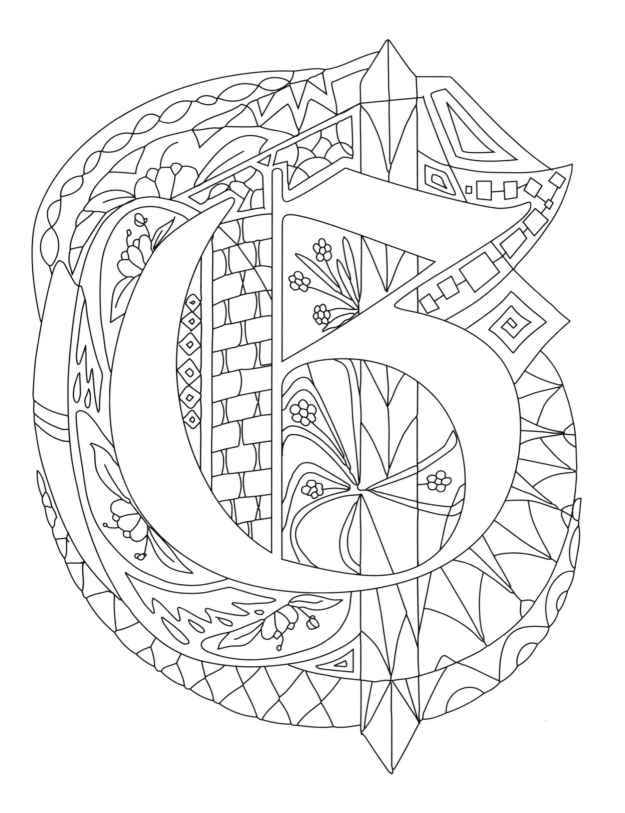

Be kind to one another, tenderhearted, forgiving one another.

EPHESIANS 4:32A [NRSV]

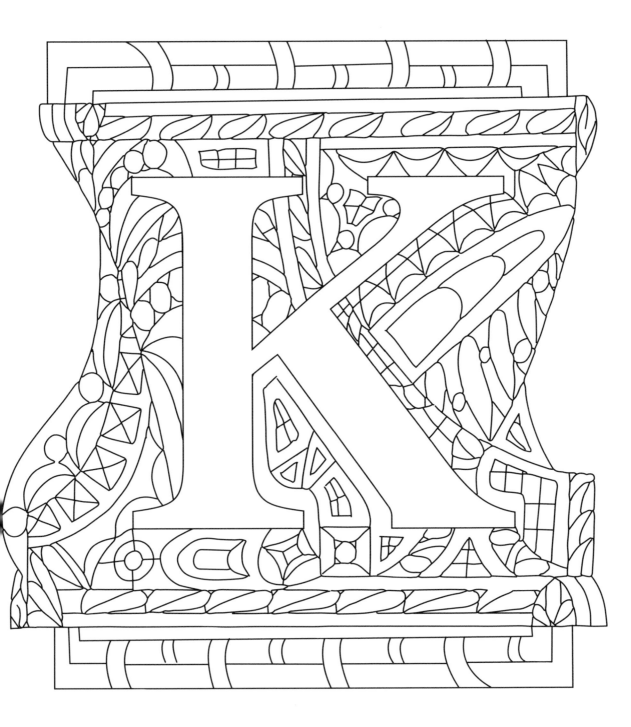

Trust God from the bottom of your heart.

PROVERBS 3:5A [THE MESSAGE]

Prayer

The Lord is near to all who call on him.

PSALM 145:18A [NIV]

Surrender

"Father . . . not my will, but yours, be done."

LUKE 22:42 [ESV]

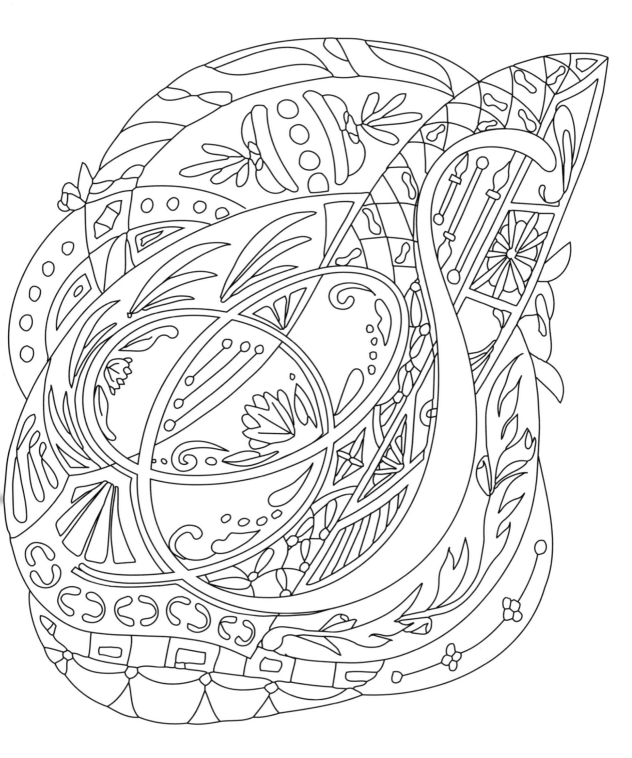

Humility

In humility regard others as better than yourselves.

PHILIPPIANS 2:3B [NRSV]

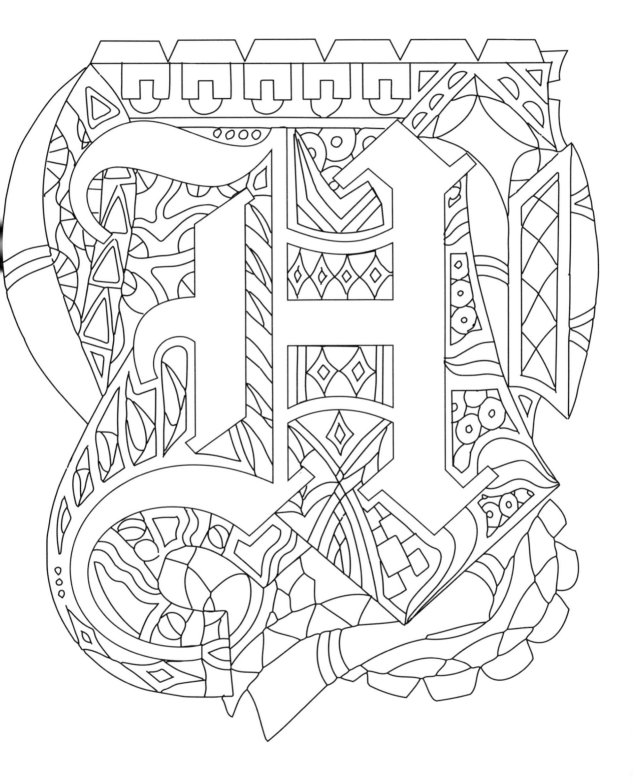

Compassion

Treat one another justly. Love your neighbors.
Be compassionate with each other.

ZECHARIAH 7:9 [THE MESSAGE]

Courage

"Strength! Courage! ... God, your God,
is with you every step you take."

JOSHUA 1:9 [THE MESSAGE]

Passion

Love the Lord your God with all your heart
and with all your soul and with all your strength.

DEUTERONOMY 6:5 [NIV]

Where the Spirit of the Lord is, there is freedom.

2 CORINTHIANS 3:17 [ESV]

Holiness

Holy, holy, holy is the Lord of hosts;
the whole earth is full of his glory.

ISAIAH 6:3 [NRSV]

Jesus said ... "I am the resurrection and the life."

JOHN 11:25 — 26 [NIV]

Our God, we give thanks to you and
praise your glorious name.

1 CHRONICLES 29:13 [ESV]

Thanksgiving

Give thanks to the Lord, for he is good.
His love endures forever.

PSALM 136:1 [NIV]

Patience

Stay with God! Take heart. Don't quit.
I'll say it again: Stay with God.

PSALM 27:14 [THE MESSAGE]